D0045254

WINNIPEG
WITHDRAWN
FEB 12 2015
PUBLIC LIBRARY

How to Mix
COLORS

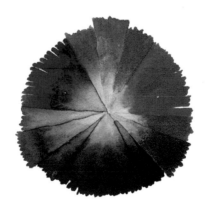

BARRON'S

How to Mix Colors

First edition for the Unirted States, its territories and
dependencies, and Canada published in 2014 by
Barron's Educational Series, Inc.

English-language translation © copyright 2014 by
Barron's Educational Series, Inc.
English translation by Michael Brunelle and Beatriz Cortabbaria

Original Spanish title: *Cómo se mezclan los Colores*
© copyright 2014 by ParramónPaidotribo, S.L.—World Rights
Published by ParramónPaidotribo, S.L., Badalona, Spain

All rights reserved.
No part of this publication may be reproduced or distributed in
any form or by any means without the written permission of the
copyright owner.

All inquiries should be addressed to:
Barron's Educational Series, Inc.
250 Wireless Boulevard
Hauppauge, NY 11788
www.barronseduc.com

ISBN: 978-0-7641-6717-1

Library of Congress Control Number: 2013944842

Production: Sagrafic, S.L.
Editorial Director: María Fernanda Canal
Editor: Mari Carmen Ramos
Text: Gabriel Martín Rig
Exercises: Gabriel Martín Rig, Marché Gaspar,
 Óscar Sanchís, and Esther Olivé de Pig
Proofreader: Roser Pérez
Collection Design: Toni Inglès
Photography: Estudi Nos & Soto
Layout: Estudi Toni Inglès
Prepress: iScriptat

Printed in China
9 8 7 6 5 4 3 2 1

POCKET ART GUIDES

How to Mix
COLORS

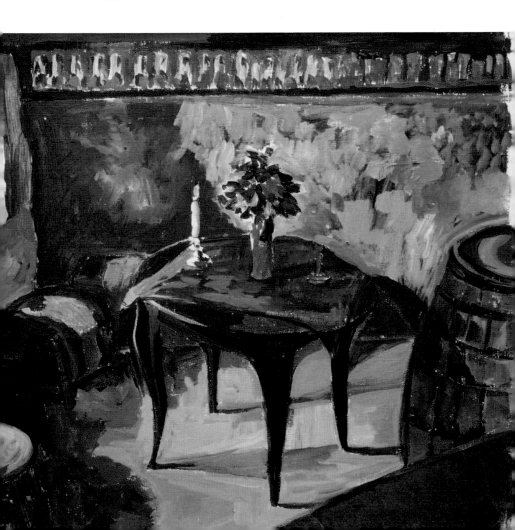

Contents

Introduction: Mixing Is the Key to Painting, 6

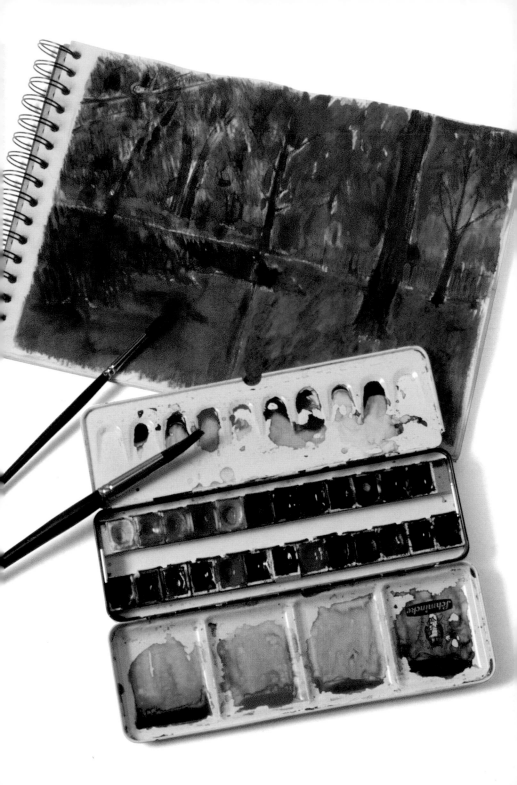

Mixing Is the Key to Painting

A multitude of brushstrokes and combinations of different colors play their part in the process of making any painting. Overlaid, blended, juxtaposed, they are used to construct the form of the actual model. To construct the form and volume of the objects that are being represented, you must create many variations of the colors, and this is exactly one of the main challenges that the artist is faced with: achieving certain colors by mixing them, especially when it is a realistic interpretation of the subject that requires a palette of very accurate colors.

Knowing how to mix the colors that you have on the palette is not just a matter of combining two or more pigments to create a particular tone. First, you must categorize the color that you have in mind, decide which colors will be used to mix it, and determine the quantity needed. Establishing the approximate proportions for each color in the mixture is essential for obtaining good results.

Artists who work with oils, acrylics, and watercolors are constantly mixing colors, either on the palette or on the support, and adjusting them as needed. The only efficient way to learn how to mix colors is to understand the behavior of the paint, its qualities, and its relationships. You must first have a solid theoretical base, knowing the possibilities of each color beforehand, and then go on to experiment and learn by trial and error. Experience in working with the palette is indispensable because it is the only way to become skilled in mixing

In this book, we explain the mixing of colors in detail and include practical exercises. The goal is to study the behavior of colors when they are mixed or applied one next to the other and also to understand how they are used to create harmony, make shapes stand out, create atmosphere, and emphasize contrasts. All these aspects are very important in using color correctly.

The Physics
of Paint

Being familiar with the characteristics of the colors used for the different painting media is the first step in creating a successful painting. Taking advantage of the chromatic possibilities of each type of paint, the way the paint is applied, and whether it can be mixed on the palette or directly on the support plays a big part in the process of selecting the colors, because this allows all the colors of a painting to be combined in a balanced and harmonious way. Following this process will also give amateur artists more confidence because they will be able to achieve more accurate results with the colors. Employing this process is helpful in choosing the colors that will be used in the mixtures and seeing how they react whether they are oils, acrylics, or watercolors, what proportions to use and what chromatic qualities they retain after drying.

Oils: Mixtures with Body

Oils are the king of paints. The colors can be mixed in several different ways to create transparent or opaque effects, or impastos, using different combinations that add subtlety and depth to the painting. However, it is important to follow certain guidelines for correctly applying the mixtures to guarantee the best results.

You cannot mix colors on a surface covered with dry paint because you will not be able to appreciate the color by itself and accurately judge it.

The most common way of combining oil paint is to make uniform mixtures of various colors.

When the palette is too full of other colors, it is best to remove some of them with a rag moistened with solvent to make a clean surface to work on.

Four Mixing Methods

There are four basic methods of mixing oil paints. The first consists of physically mixing two or three colors on the palette until you obtain a new homogenous color. The second is mixing two colors incompletely, either on the palette or directly on the canvas, so that they are striated. The third system encourages optical mixing and is achieved by combining touches of two or three adjacent colors. The final option consists of applying glazes, films of transparent colors spread over an underlying base of color.

Caring for the Palette

It is very important to mix your paint on a clean palette; otherwise, the colors can be confused with each other when some are on top of others that have already dried. This will confuse an inexperienced painter and adversely affect the results. Some artists who are purists will insist that the palette should be white in color, but this is not necessary because a color mixed on the palette will not be truly seen until it is applied to the canvas and can be seen as it interacts with the surrounding colors.

*If the mixture of the colors is only **partial,** the blend will be incomplete and the brushstrokes will be striated.*

One of the great virtues of oil paint is that it allows you to completely modulate the color by blending brushstrokes with each other.

Oils can be diluted with oil medium (Holland varnish) and then applied in thin, translucent layers that make color mixtures with the glazing technique.

Homogeneous Color or Striated Color?

Homogeneous colors made with oils must always be mixed on the palette and never directly on the surface of the canvas. It is a matter of mixing two or three colors very well with a brush until they create a new color that is totally uniform with no strands of other color.

The intensity of an orange color made by mixing alizarin crimson and cadmium yellow will never match the intensity of the same color from a tube because any mixture reduces the intensity of the colors.

1. Place two colors next to each other on the palette, and mix them very well.

2. Use rapid circular or whirling strokes, acting quickly.

3. Keep moving the brush until the homogeneous color emerges. The brush should move in a zigzag manner from top to bottom.

4. Continue mixing with the brush until the strands of the two original colors disappear to make a uniform mixture.

Mixed Colors or from the Tube?

Which is better, a color that is a homogeneous mixture or one directly from the tube? The answer depends on what the color will be used for, that is, on the intensity or amount of saturation that is required. The physical mixture of two oil colors causes their tone and purity to diminish. Thus, a cadmium orange from the tube will always be much more vivid and intense than one that is made by mixing magenta or crimson with yellow. On the other hand, colors created by mixing harmonize much better with each other than the more saturated ones out of the tube.

Controlling the Quantity

To achieve two completely equal homogeneous mixtures, the proportions of the colors should be repeated exactly. If you vary the ingredients, there will be a change in the shade of the resulting mixture. Therefore, when preparing a uniform color, you must calculate the amount of mixture needed to cover the entire surface that you wish to paint, and, additionally, foresee possible problems and difficulties in case you have to reproduce the same color in the future.

A landscape sketch made with homogeneous applications of color. You can see the colors used across the top.

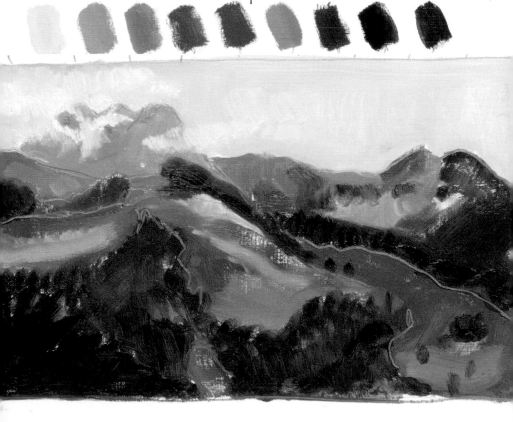

Striated Mixtures

Incomplete mixtures of oil colors are used for expressive purposes. They are made by blending several colors with a brush or spatula, allowing the paint to form streaks or strands of color so that all the colors used in the mixture are still visible.

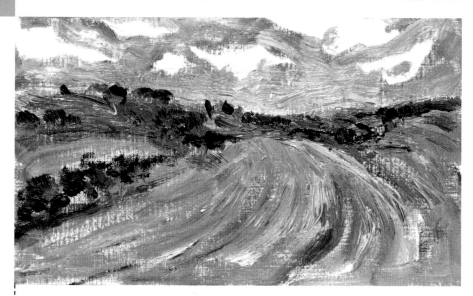

Some artists achieve the effect of broken color by *applying barely mixed colors or striations, making short, overlaid brushstrokes in all directions.*

The bristles of the brush spread the colors used in the mixture to form fine and textured streaks.

Striated colors are created by partially mixing the paint on the palette. Applied to the canvas, they add greater expressivity and the effect of broken color.

Partially Mixed Colors with a Brush

The creamy consistency of oil paint encourages striated mixtures of colors, made by mixing them just partially on the palette without diluting them. The result is a mass of paint that forms striations of different colors. It is applied to the canvas just like uniform mixtures, but the results are much more irregular, fragmented, and dynamic. If the brush is made of hog bristles, the streaks caused by dragging the brush will be added to those of the streaks of color. When a surface painted in this manner is observed from a distance, the different streaks of color are mixed optically.

Mixing with a Spatula

When working with a spatula, it is typical for the paint to be partially mixed, which creates an effect that is more active, textured, streaked, and powerful. A surface painted using a spatula is full of active mixtures of color, consisting of thick paint that forms a sort of bas-relief. Most of the colors remain unmixed. A good approach for mixing paint with a spatula is to use a limited color palette, from eight to ten colors at the most. If you use too many colors, it will be more difficult to control and coordinate the mixtures.

If you want a more homogeneous or gradated treatment, you only have to stroke several times with the spatula to blend the mixture.

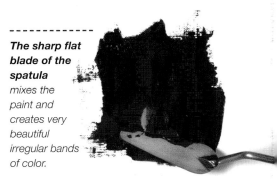

The sharp flat blade of the spatula mixes the paint and creates very beautiful irregular bands of color.

Mixing oils with a spatula is done partially on the palette and then finished on the canvas, carefully controlling the direction that the spatula is dragged.

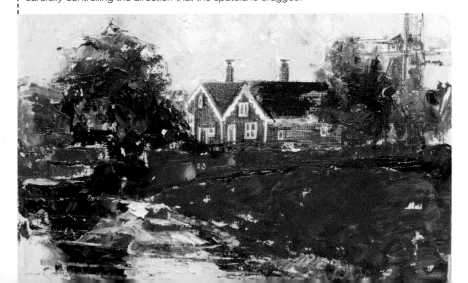

Paul Signac

(1863-1935)

Signac's work champions the use of optical mixtures in the Pointillism style.

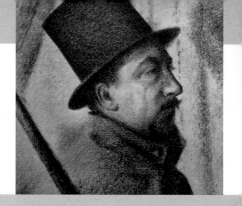

POINTILLISM:
OPTICAL COLOR MIXING

The Papal Palace, Avignon *(1900)*
In this scene on the banks of the Rhone River, the artist used the Pointillist technique directly mixing the different colors on the surface of the canvas with short overlaid brushstrokes. He used saturated colors that were barely mixed on the palette and juxtaposed them on the canvas like a mosaic. Seen from a distance, they seem to mix in the viewer's eye while conserving the brightness of the original colors. His brushstrokes almost effortlessly trace a geometry that makes his paintings a model of order, clarity, and careful planning.

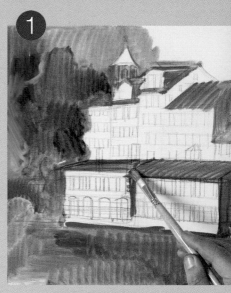

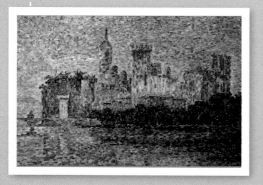

1. Over a drawing sketched in pencil cover the white of the support with strokes of very diluted paint. The forms are a geometry of pure masses with a blend of nearly pure and barely mixed colors.

The son of a well-off family, Paul Signac initially aligned himself with the Impressionist painters because of his great interest in light and color, but beginning in 1884, after becoming friends with the painter Georges Seurat, he moved to neo-impressionism, also known as Pointillism. Over the years, he adhered less strictly to the Pointillist technique and began using larger brushstrokes that were longer, thicker, and more structured.

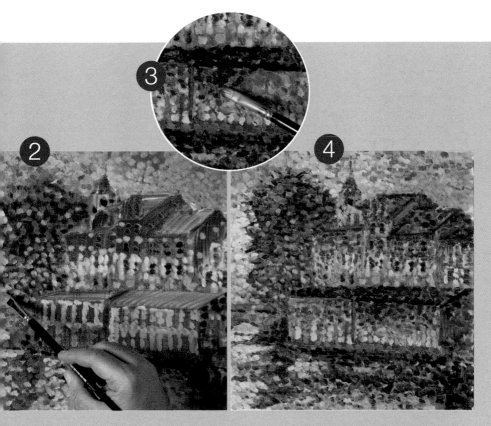

2. Allow the diluted paint to dry before adding small touches of purer colors, placed closely together. While you paint this sketch, pay close attention to the distribution of colors in the original model.

4. In this painting, the task of mixing does not take place on the palette itself, but on the surface of the canvas. Here the dabs of color mix optically to create an active and dynamic surface.

3. The dabs of paint should be smaller and smaller, thick and with cleaner and more vibrant colors. Paint them over the previous colors to highlight the areas of light.

THE SUBJECT

Transparencies and Glazes

Mixing oil colors by glazing is done by superimposing one film of transparent color over another that is already dry. In this technique of applying one color over another, you will inevitably produce a third color through transparency. The glazes are an ideal way to create smooth transitions of color in an oil painting, although it is necessary to dilute the color with an oil medium to accelerate the drying of the paint.

Mixing with glazes consists of modifying one color with thin translucent layers of another color.

One of the most interesting effects of this type of mixing is created by colors that are applied in thin overlaid washes.

The paint underneath should be dry before applying a new glaze.

The more liquid consistency of oils diluted with varnish allow you to create wet mixtures that will form gradations between two colors.

The Most Appropriate Colors and Their Application

When you work with glazes it is best to use colors that tend to be transparent in the mixtures, like vermilion, lemon yellow, and quinacridone pink. The glazing does not necessarily have to be uniform; it can be applied to create gradations, blending different colors and smoothing the edges of the different amounts of gradation with a varnish. A soft brush is generally used for working on a previously painted surface. If you wish to lighten areas or apply some highlights, you can absorb some of the glaze by going over it with a brush dampened with essence of turpentine.

Drying Time

After applying each glaze, you must allow it to dry completely before adding a new layer. This means that creating an oil painting with this technique can require several days. It is not a good idea to paint oil glazes using turpentine, since this solvent tends to affect the consistency, make the colors gray, and reduce their brightness. It is best to mix the paint with a glazing medium that will make the color more transparent, like dammar varnish or cobalt dryer.

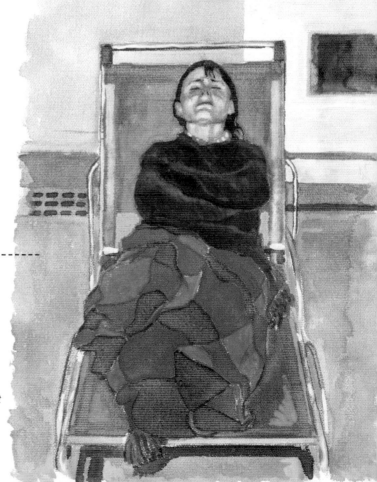

When light penetrates the transparent film of color it reflects on the paper and creates a rich and intense effect. That is what is happening in this painting, made with only the five colors that are shown above.

THE SUBJECT

Watercolor: Wetting Is Mixing

One of the fundamental aspects of watercolor paint is its ability to reflect the chromatic characteristics of each pigment in its purest and most luminous state. This is because the pigments are ground more finely for this medium than for any other. This particularity results in the quality and luminosity of any of the colors that you mix.

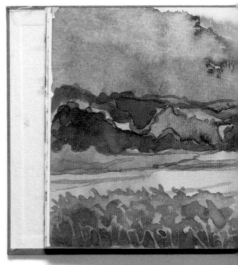

In watercolors, white does not exist; *the only way of making a color lighter is by adding a greater amount of water.*

The artist's palette has a few dark colors; *however, most watercolors are light and can be darkened by overlaying washes or by mixing light colors with each other.*

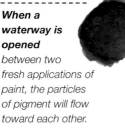

When a waterway is opened *between two fresh applications of paint, the particles of pigment will flow toward each other.*

Accidental mixtures of color *on the surface of the paper are the main advantage of watercolors.*

No Need for White

In painting with watercolors, white is not used to lighten colors. The colors are lightened by adding water. Varying the amount of water that is added to the paint will create a range of different tones, from light to dark. Thus, if you desire a lighter tone you should add more water rather than white paint. Water is the main vehicle for mixing. If you add a wash of clean water between two adjacent applications of wet color, one pigment will flow through the water to meet the other pigment and mix with it lightly.

Dark Watercolors

Watercolor paint is bright by nature because it is transparent and the white of the paper underneath is reflected through it. Colors that are very dark are not frequently used, so it is not necessary to buy a wide range of browns and grays for painting because many of these variations can be made by mixing the three primary colors in different amounts. Different tones of blue, red, and even yellow and orange can be used to create a full range of dark colors.

Watercolors require very subtle mixtures made with few colors. By following this principle, you can create watercolors that are bright with soft and sweet values.

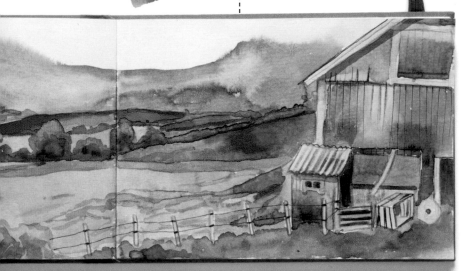

Mixing on Wet and on Dry

It is not necessary to use a large palette of colors, nor many different techniques to paint with watercolors. You can use just three or four techniques to apply the colors, depending on the effects that you wish to achieve. Using a range of just eight well-chosen colors and some good brushes you can create a great variety of colors by mixing.

This female nude was painted on dry paper. Washes of violet, crimson, cobalt blue, and indigo blue watercolors were applied over each other.

When working on dry, you will not see gradations; the figure emerges from applying layers of different colors that will cause the contrasts to appear.

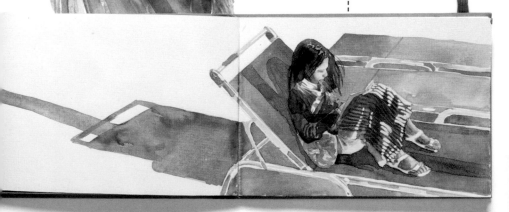

Mixing on Dry

There are two basic ways of mixing watercolors on dry. The first is with washes. The paint is diluted with water until you arrive at the desired tone; then it is applied over another color that is already dry to produce a new one. It is not a good idea to make more than three washes of color; otherwise, the results can be spoiled. With this method, the colors are mixed only on the palette.

Mixing on Wet

The ability to mix and blend the colors wet is one of the main advantages of watercolors. This approach consists of applying a color over a wash of another color while it is still wet, so that both colors come into contact with each other. As the two washes blend, a new color is created. Even if the resulting color is predictable, the shape of the gradations and the transitions from one color to another are not.

On occasion, when you mix several colors on wet, the resulting wash is granular; this happens because the pigment of one color is heavier than that of the other. Rather than being a defect, this becomes a technique for creating textures.

Mixtures of several colors on wet are the main advantage of this medium. For them to be effective, it is important that the colors are strong and that plenty of water is used.

Your Own
Color Chart

It is a good idea to practice a lot before starting to paint so you will have a good understanding of the possible color mixtures. Color mixing charts offered by manufacturers are helpful guides for the beginner, since they show the possibilitie

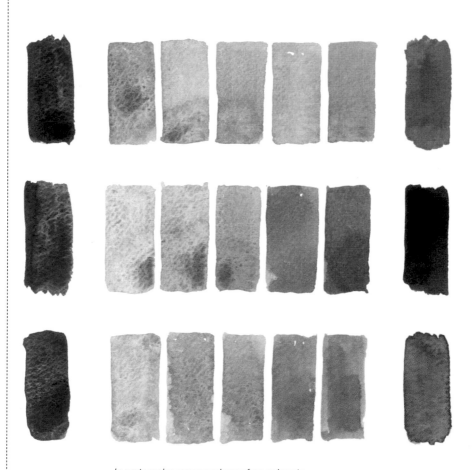

In watercolor, you need very few colors to create a large chart. Notice the variety of tones made by mixing different amounts of ochre, red, and green.

of each color. However, you will learn more if you mix the colors yourself and make your own chart. It is enough to slightly mix one color with another to see that, with very little, you can achieve a wide range of shades. The charts that you make can be kept and used as references for making new mixtures or for creating an archive of the mixtures of colors that you are able to achieve.

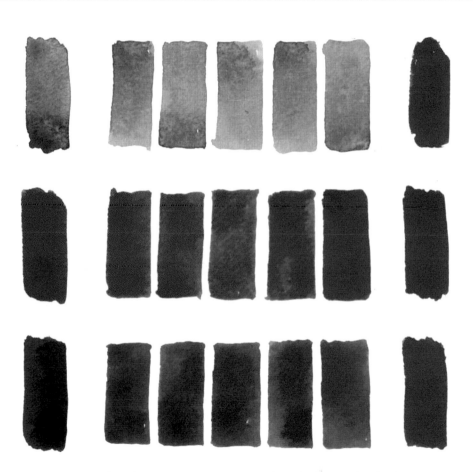

Cadmium yellow is traditionally considered to be a weak color that will be immediately absorbed by other more intense colors, but it is capable of producing numerous shades when mixed with red, green, and violet.

Boats in a
Range of Blues

In this exercise, we show you how to apply watercolors from the same range, specifically how to

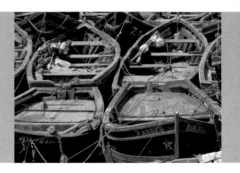

This interesting scene shows small boats painted with a range of strong blues.

①

1. Draw the model with an HB graphite pencil. Go over the shapes with a heavier line, using a cyan blue water-soluble color pencil. Each line should be clearly marked.

②

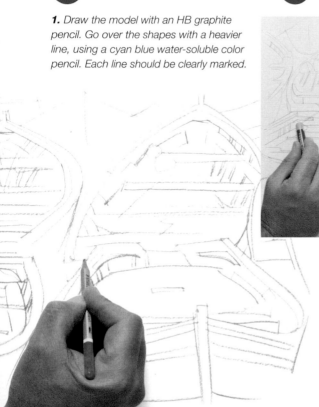

2. Before starting to paint, reserve the ropes and cables that hang from the boats. Use a stick of oil pastel that will repel the water for this purpose.

mix three kinds of blue with each other: ultramarine, cyan, and indigo. Ultramarine blue is one of the blues most used by artists, its slightly violet tone and deep rich tint is highly appreciated. Cobalt blue is more neutral. Cyan looks much fresher and adds a large amount of luminosity if it is mixed with other blues. Indigo blue is the darkest of all, and it can be an extraordinary counterpoint for creating contrasts and shadows. This exercise is an example of the simple harmony that can be created by the exclusive use of blue with a wide range of variations.

USING A RANGE OF SIMILAR COLORS

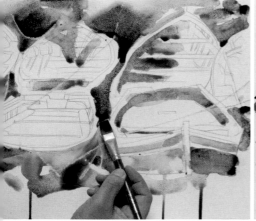

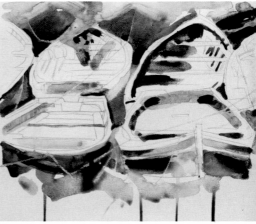

3. Using a flat brush charged with indigo blue, apply a preliminary general wash that will only determine the darkest areas, the ones that will be in the shadows.

4. Once the previous layer of paint is dry, darken the tones with the same color, but this time use a fine brush so you can begin indicating the shapes of the boats.

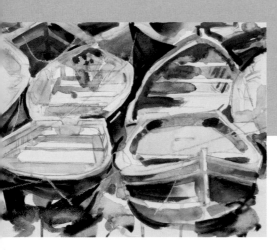

5. *Next, use cyan blue to paint the illuminated areas of the boats, leaving the most brightly lit parts of the boats white. In some areas, mix the cyan blue with wet indigo to create light gradations.*

6. *Use a fine round brush charged with ultramarine blue to add some details. They should be applied on dry to indicate the shadows and mixed with cyan blue to extend light gradations on the decks of some of the boats.*

 5 6

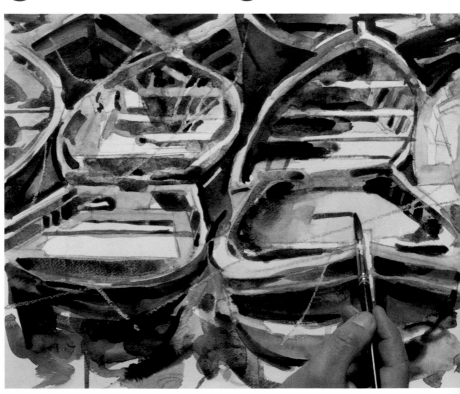

7. *Using the same brush, now charged with very saturated indigo blue, darken some corners and add a few linear shapes to emphasize the structure of the boats.*

8. *The last addition of lines creates a more solid look, without losing the fresh feeling of the sketch. The limited mixture of colors and the dripping and looseness make for a simple yet very expressive representation.*

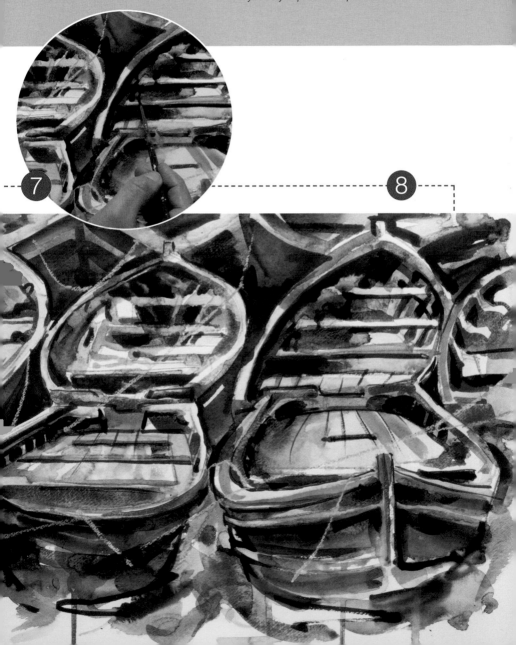

Acrylics: The Hybrid Paint

Acrylics are known for their versatility and their permanence. They can be used for everything from glazes or subtle washes like those achieved with watercolors to opaque and impasto applications like those made with oils. Because of these characteristics, it was considered a hybrid, halfway between the other two media. Over time, however, acrylics have become recognized as a proper medium, a title which it has full right.

Acrylic paints have the ability to go from a very creamy consistency to a watery one by just adding a greater amount of water to the paint, which makes it a very versatile medium.

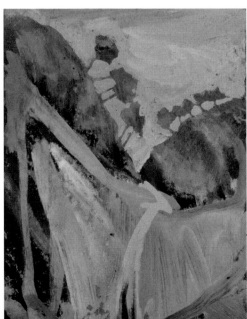

When you mix paint directly on the painting the drying time can be a problem. On the left is a gradation that was made in place (a); on the right, the artist waited one minute before applying the second color (b). The first color dried and was not able to be mixed.

Artists who are accustomed to painting with oils need a little time to get used to using acrylics precisely because of their quick drying time. However, this feature offers many new opportunities for working with color.

Mixing with Acrylics

Two acrylic colors can be blended or mixed on the support in the same way as oils; however, the difference in their drying times can be a problem. Acrylics leave less time for mixing, manipulating, and correcting brushstrokes, so it is preferable to mix less paint than with oils so that they will not dry on the palette. Later on, you can prepare more paint when you need it, and the addition of clean paint will refresh the colors on the palette and keep them soft and manageable.

Advantages of Mixing with Transparencies

If you dilute acrylics with a lot of water, the result will be translucent washes, and you can create work that is similar to watercolors. However, even though you can make paintings that look like oils or watercolors, acrylics should not be thought of as a substitute for the two. The advantage of acrylics, when mixed using transparencies, is that you can overlay all the thin washes that you want without dissolving or removing the paint underneath. By superimposing a couple of washes of pure colors, you can create a third color that will be much richer than any mixture made on the palette.

Acrylics are a medium that is very useful for mixing colors by overlaying glazes or washes.

Acrylic colors are attractive and saturated when one is juxtaposed with another.

When overlaid, acrylics maintain their intensity while they are wet, but they become more transparent and lose their brightness when they dry.

First Mixtures Using Flat Brushes

For the artist to understand the essence of mixing and the importance of discovering and creating the color of the real model, he or she must ignore the details and shades and concentrate on the chromatic essence of the different parts of the painting. For this reason, we offer a series of exercises with acrylics using wide flat brushes, which will keep the painting of colors from becoming too complicated and will cause the artist to concentrate on creating an image using very simple mixtures of color.

Acrylics applied with a flat brush *will show the marks of the brush because of the thin consistency of the paint.*

The brush is too wide to represent details, *so the artist will apply flat brushstrokes while focusing on only the color mixtures.*

The best way of controlling mixtures made with acrylics *is to work with flat brushes and to use them to develop tonal scales. The different shades of orange used for representing this piece of fruit are a good example of this.*

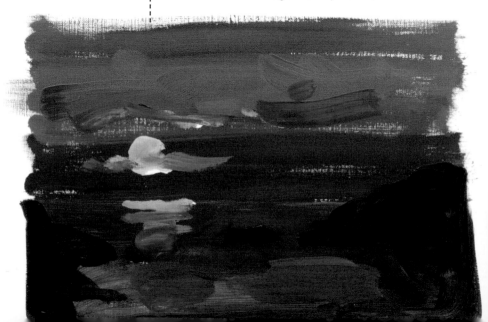

Simplifying the Mixtures

If you work with a flat brush, you will basically be forced to focus all your attention on shape and color. With the use of washes and wide bands of color, you can make both elements relate quite well in each one of the following exercises. You should use three or four colors on the palette that will be mixed with a soft wide brush. Mix the colors to represent each object and use them to establish the general shapes.

Streaky Brushstrokes and Bands of Color

In the following exercises, the tones are limited. Simplification always can be used as a good starting point, a first step for developing the theme with additional color mixtures. Slightly mixing different colors is an alternative approach for making a preliminary sketch. When you work with a flat brush, not all the mixtures have to be made on the palette; you can charge the brush with two colors at the same time to create a streaky brushstroke or a wide stroke that shows two or more bands of color.

In most paintings done with acrylics, *the first, most uniform mixtures are later covered with applications of thick opaque paint.*

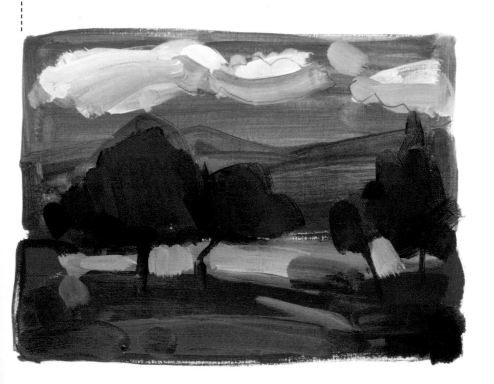

Paul Gauguin
(1848-1903)

Paul Gauguin was born into a middle class family. In 1883, at 35 years of age, his obsessive interest in painting led him to abandon his family and

Still Life with Onion and Japanese Print *(1889)*
This still life with onions and turnips is reminiscent of Cézanne (whom Gauguin greatly admired) in the way that he constructed the volumes of the vegetables, applied colors barely mixed on the palette to create tonal scales and gradations, and also used the characteristic blue background with a very distinct brushstroke that contrasts with the elements in the foreground of the painting. It is interesting to see how Gauguin emphasizes the silhouettes of the elements with a dark line, influenced by the cloisonné technique and leaded windows, techniques used in the stained glass and enamels of the era.

The work of Gauguin is considered to be some of the most important of all the French painters of the 20th century.

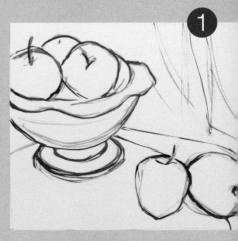

1. You will paint a still life according to the style of Gauguin. It will be based on a bowl of fruit drawn with charcoal and painted over with blue oil paint.

EMPHASIZING THE OUTLINES

work to fully dedicate himself to art. His first attempts are reminiscent of the Impressionist style; however, when he came into contact with Émile Bernard, whose style would be a decisive influence, he distanced himself from Impressionism and began experimenting with new sources of expression.

From that point on, his paintings are characterized by an unconventional use of color, which he applied in their purest and brightest forms, not at all realistic, and he did not use much shading, reducing dark shadows and emphasizing the outlines of objects.

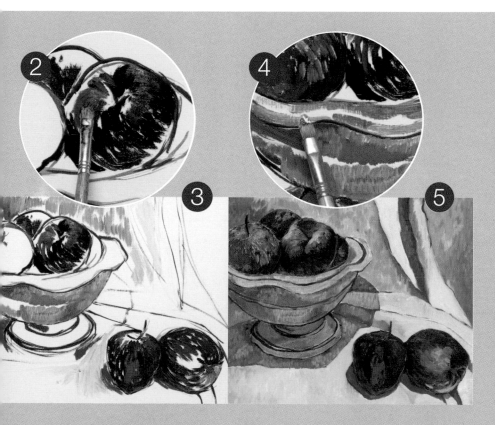

2. The thick brushstrokes of oil are mixtures of crimson, yellow, orange, white, and a dab of violet on the red apples. The strokes are placed next to each other.

3. Cover the background with blue mixed with white and then project the shadows of the fruit. The brushstrokes should be short, narrow, and very visible and applied alongside each other.

4. The colors look more mixed on the bowl: create some grays by blending red, green, and white, and apply lightened ochre in the illuminated areas.

5. To finish, add some new colors made by blending greens and oranges on the apples, and gray blues with green blues in the shadow projected by the fruit bowl.

Combining
and Blending Colors

The range of colors available on the market is so great that you do not even have to make the most basic mixtures if you wish to save time. However, a palette that is too large can cause the artist either to become lost among so many tones or to limit the work to the use of very standardized colors, losing the richness of tones and never delving into the fascinating world of color. In this part of the book, we will explain in detail the craft of mixing. To do so, we must first make some previous explanations of the characteristics of some of the color families and then note several techniques for increasing the color palette, like dulling and saturating, lightening and darkening the colors correctly. In essence, we will supply you with the techniques for developing an endless number of colors in a clean and efficient manner.

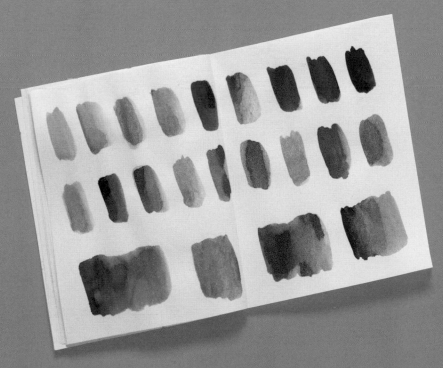

Summary of **Color Mixing Theory**

The theory for mixing colors is based on the color wheel, a simplified version of the light spectrum, which is a classical approach that is used for illustrating the relationship between the most important colors of the spectrum: yellow, orange, magenta, blue, green, and violet.

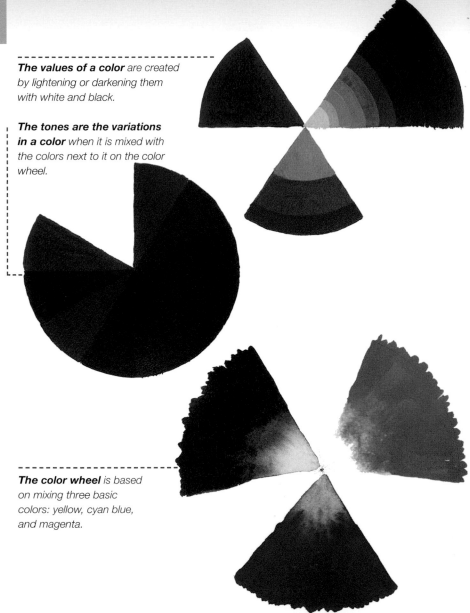

The values of a color are created by lightening or darkening them with white and black.

The tones are the variations in a color when it is mixed with the colors next to it on the color wheel.

The color wheel is based on mixing three basic colors: yellow, cyan blue, and magenta.

Primary and Secondary Colors

The color wheel is an important reference for the artist. It is a simplified version of the wide spectrum of sunlight contained in just a few colors. The color wheel is organized into three primary colors (magenta, cyan blue, and yellow), which can be mixed to create the colors located between them, the secondary colors (orange, green, and violet). The tertiary colors are obtained by mixing a primary color with the nearest secondary on the color wheel. By varying the proportions of each mixture, or adding small amounts of other colors, the range of colors becomes almost infinite.

Scales of Tone and Value

By varying the proportions when mixing two primary colors you can obtain a wide range of subtle tones. The tone or shade is an attribute of color that is equivalent to the distance this color moves toward its neighboring color. Thus, a yellow can have a green tone or an orange tone. And the range of mixtures can be enlarged even more if you create transitions from dark to light, which are referred to as values. This means that if you add different amounts of black or white to any color on the palette, you will change its value, but you will not alter its tone or shade. The possible scale ranges from a very light color to its darkest version.

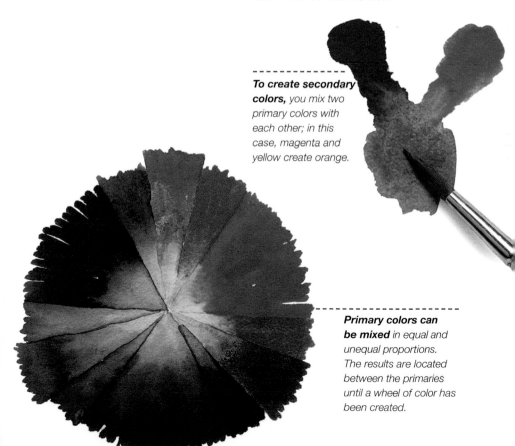

To create secondary colors, you mix two primary colors with each other; in this case, magenta and yellow create orange.

Primary colors can be mixed in equal and unequal proportions. The results are located between the primaries until a wheel of color has been created.

A Scene with Just **Three Basic Colors**

This pair of tropical birds with brightly colored feathers is a good excuse for making mixtures of primary colors.

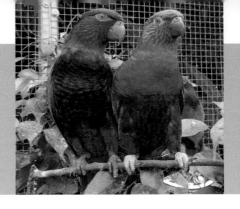

The colors used in this exercise are *cobalt blue, quinacridone red, and cadmium yellow.*

1

2

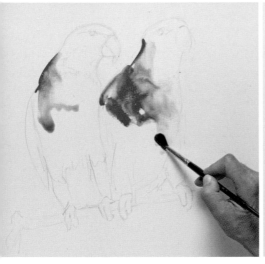

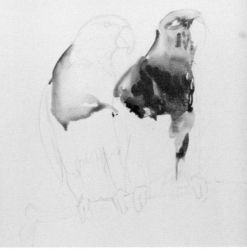

1. *Make a pencil drawing of the model; then apply pure yellow over it. The different tones of this color are made by diluting it with water.*

2. *Use cobalt blue to paint the head, and use red for the breast. Where the red comes into contact with the wet blue and yellow they will run together to form violet and orange.*

The use of the color wheel can be limiting for artists when they are trying to mix certain paints because the pigments, unlike light, are not pure; however, it is a good starting point for understanding how the three basic colors interact and applying the mixtures in a real exercise. Next, we encourage you to play with the basic colors using watercolors, which, when mixed in different proportions, allow you to develop a wide range of different colors and tones. It will be a good idea to work with very simple mixtures to preserve the bright colors of the tropical birds.

- -

Here are the three main mixtures on wet that are used for the colorful plumage of the birds. There is no need to brush the washes since they will mix when they come into contact with each other.

③ 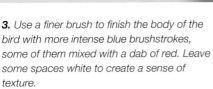 ④

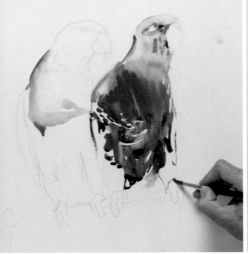

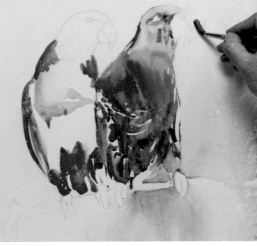

3. Use a finer brush to finish the body of the bird with more intense blue brushstrokes, some of them mixed with a dab of red. Leave some spaces white to create a sense of texture.

4. Mix the yellow in unequal quantities, which will help indicate the form of the bird on the left. Prepare a very diluted violet color for covering the background; if you add a touch of yellow, you will create a brown tone.

5. *Darken the violet in the background, at the feet of the birds, which will help outline the branch. Any dripping should be absorbed with a paper towel.*

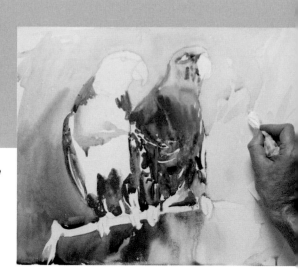

6. *Paint the head of the bird on the left with gradated red and violet, and the body with red and a touch of yellow. All the colors should be applied unmixed, the mixing will take place directly on the paper.*

5 --------- 6

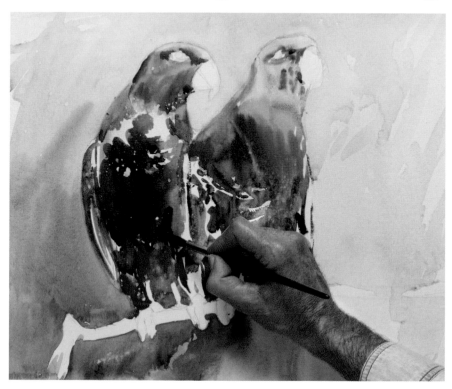

A PALETTE OF THREE PRIMARY COLORS

7. *After the body is finished, work on the eyes and the beak with a fine brush, which will give more precise results.*

8. *The eyes look orange in color, but the iris is darker, made by mixing three colors. The branch is a light ochre, created by adding yellow to violet and then diluting them with water.*

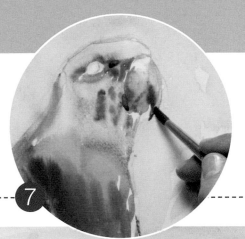

7

8

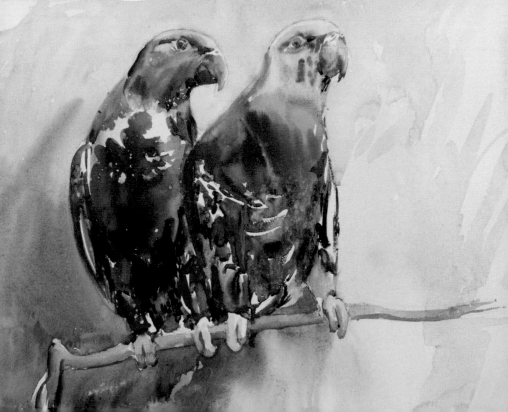

Bright **Colors**

When you mix the three primary colors on the color wheel to obtain secondary colors, like green or orange, the results can be disappointing, because the orange will look somewhat more dull, and the green can even seem muddy. In this chapter, we will explain how to keep these mixtures from looking muddy and how to maintain the bright and saturated look of the colors.

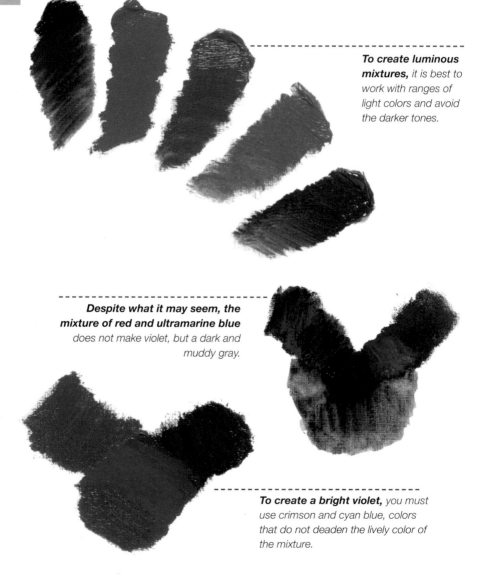

To create luminous mixtures, it is best to work with ranges of light colors and avoid the darker tones.

Despite what it may seem, the mixture of red and ultramarine blue does not make violet, but a dark and muddy gray.

To create a bright violet, you must use crimson and cyan blue, colors that do not deaden the lively color of the mixture.

Muddy Colors

Everyone knows, in a general sense, about color-mixing theory, but in practice some combinations turn out to be somewhat muddier than expected. For example, if you mix cadmium red and ultramarine blue to make violet, you will create a very undefined dark color. The same thing happens when you mix a dark warm color with a touch of a cool color like blue or green; it will decrease its intensity and (in greater quantities) become gray. From this we can deduce that two opposite colors produce neutral tones, that is to say, browns, grays, and ivories.

Maintaining Lively Colors

To create clean mixtures, you must choose the right colors, so the results will be strong and bright. Next, we will indicate which colors will make cleaner tones when they are mixed with each other: alizarin crimson, magenta, cadmium yellow, cyan blue, light green, and emerald green. On the other hand, you must avoid using white to lighten colors and the earth tones to darken them; it is best to resort to ochres and yellows to lighten and darken colors of the same range for darkening. Thus, to darken orange, it is best to use crimson instead of burnt umber. Doing this will preserve the brightness of the color despite the mixing.

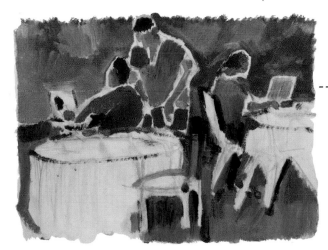

Sketch made with a mixture of muddy colors. The use of dark colors reduces saturation, and the intensity of the tones is lost.

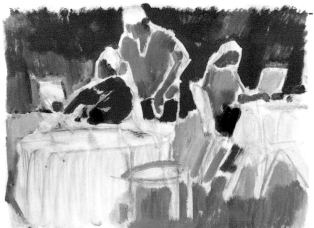

This other color sketch was made by combining brighter tones and avoiding the use of more than two colors in each application. The colors will then be more luminous and conserve a greater amount of saturation.

Darkening with **Earth Tones**

At first glance, combining earth tones with blues might seem somewhat unnatural, but the two ranges are complementary. When they are mixed you will create interesting gray tones that turn out to be very useful for shading or darkening other colors. In addition, the earth tones are generally used for reducing reds, yellows, and greens that are excessively saturated.

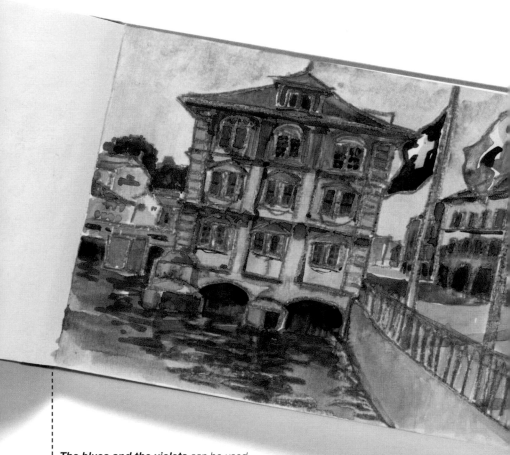

The blues and the violets can be used for modulating the earth tones. Despite the differences, blues and browns complement each other very well.

The Most Important Earth Tones

All the earth tones are very solid colors that should not be absent from the painter's palette. Yellow ochre is very luminous and is often used for lightening or reducing the saturation of green colors. Raw sienna is a yellow brown that adds middle tones, a clean and transparent chestnut color. Burnt sienna is somewhat darker and reddish; it is useful for darkening greens and blues. Burnt umber is one of the darkest earth tones, very useful for creating deep shadows and darkening the previously mentioned earth tones.

Mixing for Shading

If you do not have pure earth tones on your palette, there are alternatives. The Impressionist painters were the first to reject the use of the earth tones and of black for darkening a color. To create the color of the shadows they mixed two complementary colors, which neutralized each other and created grays or neutral browns that were better integrated in the work and offered a marvelous contrast to the more saturated colors.

The mixing of blues and earth tones *creates a rich and varied range of grays.*

The four indispensable earth tones, *those every painter should have on his or her palette, are yellow ochre (a), raw sienna (b), burnt sienna (c), and burnt umber (d).*

Cityscape with
Earth Tones and
Ultramarine Blue

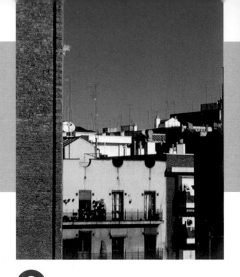

The chosen scene should be simple so you can focus on the mixtures and not complicate the matter with a perspective drawing.

1

2

1. Draw the scene with a well-sharpened graphite pencil. The sky is clear, and there are numerous architectural details that must be drawn geometrically on the rooftops and façades.

2. Paint the sky first, filling the entire space with a wash of ultramarine blue, which should be applied irregularly, leaving small areas where the white paper shows through.

Mixing two or three earth tones with ultramarine blue will create a harmonious and well-coordinated color range. The structure of the following exercise can be done, basically, with three earth tones: ochre, burnt sienna, and burnt umber. Ultramarine blue is mainly used for tinting the sky, creating grays, and shading the tones of the earth colors. A touch of crimson is added to this mixture to bring the blue toward more violet tones. This cityscape will be done with watercolors.

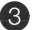

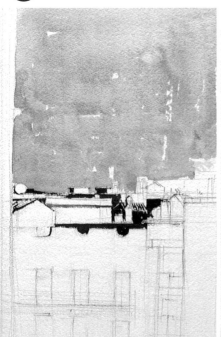

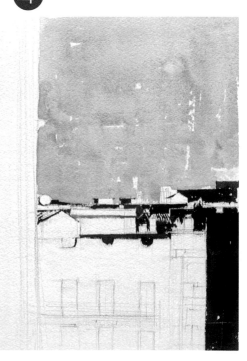

3. *Add a touch of blue to the burnt umber to create a dark tone that you will apply to the shaded parts of the rooftops. Work with a fine round brush so that the lines are straight.*

4. *Now add a touch of crimson to continue creating the contrasts of the building on the right, which is completely in shadow because it is backlit.*

5. Use washes of sienna to begin applying, in a simple and flat manner, the intermediate tones that define the color of the rooftops. The most illuminated spaces are left white.

6. Use a fine brush to apply some dark sepia tones and gray (made by mixing sepia with blue in different proportions) to the windows and the balconies on the façades.

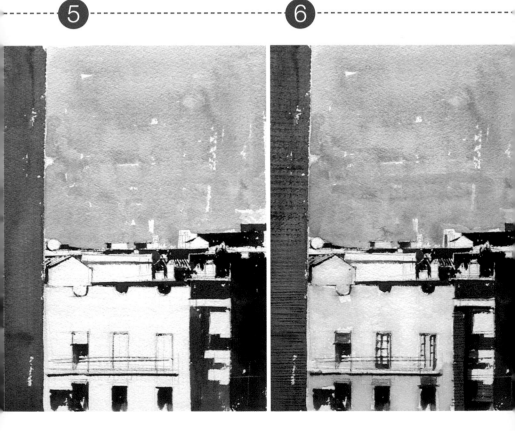

A HARMONIOUS AND WELL-COORDINATED
COLOR RANGE

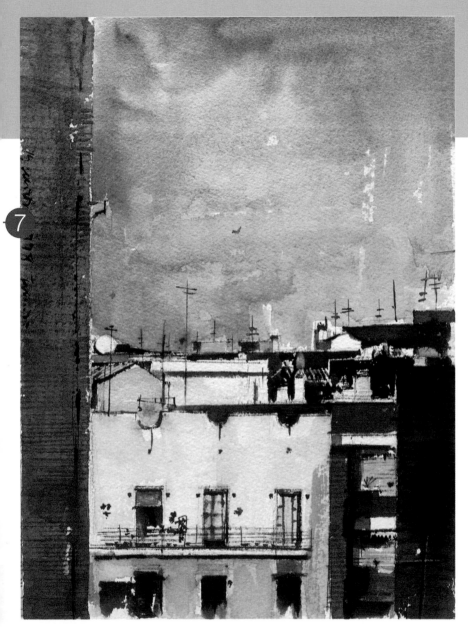

7. *Mix crimson and ultramarine blue to apply very light violet washes on the façade and in the sky, helping to integrate the overall colors. The whites should be covered with very diluted ochre, slightly shaded with the previously used violet. When the sky is dry, add the antennas with a very fine brush, carefully and with the help of a ruler.*

IN THE MANNER OF:

Peder Severin Krøyer
(1851-1909)

Born in Norway and artistically trained in Denmark, Krøyer is considered one of the greatest Scandinavian painters of the second half of the 19th century.

SOFT AND SOMBER SHADES

Peder Severin Krøyer is one of the most respected and colorful painters of the Danish-Norwegion community in Skagen.

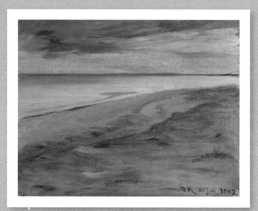

The Beach Skagen *(1902)*
This work is associated with the coastal locality of Skagen, an old remote fishing village on the northern part of the Jutland peninsula, where many artists went to be inspired by the local daily life and the coastal landscapes. The best-known works of Krøyer are representations of the beach at Skagen during the late afternoon. They are characterized by a limited color range and fresh brushwork, done with an untraditional palette. This scene represents the typical colors used by Nordic artists: soft and melancholy tones that instill the desolate beach scene with calm, sadness, and loneliness.

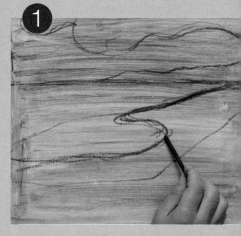

1. Apply a base of blue acrylic mixed with a little burnt sienna to give it a grayish tone. When the color is dry, sketch the clouds and the outline of the beach with vine charcoal.

After completing his studies at the Royal Danish Academy of Art, he traveled Europe from 1877 to 1881 to become acquainted with all the art movements. In Paris he absorbed Impressionism, where he shared experiences with Monet, Degas, Renoir, Sisley, and others. Upon his return to Denmark, he took up residence in the coastal town of Skagen, where he developed a style of painting that is unique in its treatment of light, which gives his paintings a colorist aspect, but also with a melancholy touch that is very characteristic of painters from Northern Europe.

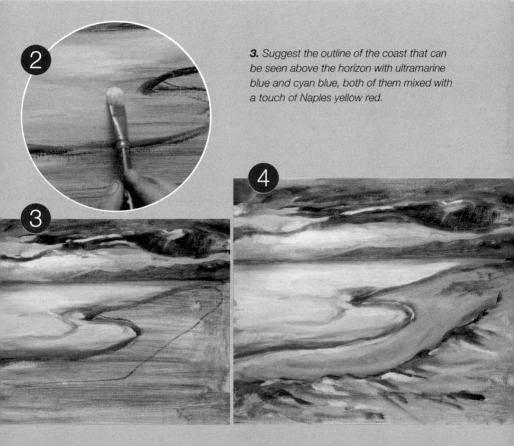

3. Suggest the outline of the coast that can be seen above the horizon with ultramarine blue and cyan blue, both of them mixed with a touch of Naples yellow red.

2. Use oil paint for the sky, a mixture of ultramarine blue, turquoise blue, Prussian blue, and Naples yellow red, all quite lightened with white. The brushstrokes should be broad and nervous. Use Naples yellow red with a large amount of white to make a gradation on the water.

4. The neutral and gray colors of the sand in the foreground are made by mixing sienna and lightened ochre with blue in different proportions. The feeling of the painting should be very sketchy, even allowing the original base color to show through.

Neutral Color
Mixtures

In practice, knowing how to mix complementary colors to develop different ranges of gray and earth tones comes with experience.

The natural tendency of a painting made with a range of neutral colors is grayish, and in it the colors can even seem dirty and dull. Practice with the palette helps you

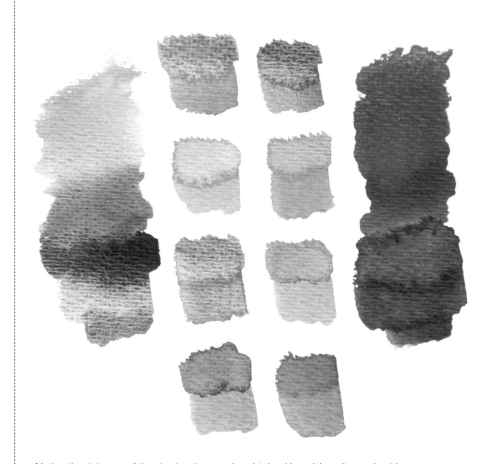

Notice the richness of the shades that can be obtained by mixing ultramarine blue and cadmium orange, varying the proportions of the colors and their dilution with water. The range of grays and browns created shows very interesting variations.

become accustomed to these exceptionally harmonious colors and delve deeply into them. The mixing of a neutral color with any other color will result in another neutral color. The following exercise consists of studying the neutral ranges that can be created by mixing just two complementary colors with each other using watercolors.

This time the neutral range will be created by mixing cadmium yellow and violet. This results in a range of ochres and browns that are more or less warm.

THE SUBJECT

Working with **Yellows and Ochres**

Of all the colors, yellow is the most fragile, the weakest one on the palette. Its coloring power and value range is very limited, and it loses its essence as soon as it is mixed. Therefore, it is best to shade it using very little of another color, barely dabbing it with the tip of the brush so you will not lose its original chromatic tendency.

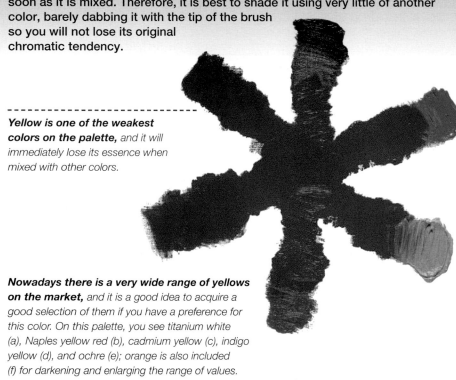

Yellow is one of the weakest colors on the palette, and it will immediately lose its essence when mixed with other colors.

Nowadays there is a very wide range of yellows on the market, and it is a good idea to acquire a good selection of them if you have a preference for this color. On this palette, you see titanium white (a), Naples yellow red (b), cadmium yellow (c), indigo yellow (d), and ochre (e); orange is also included (f) for darkening and enlarging the range of values.

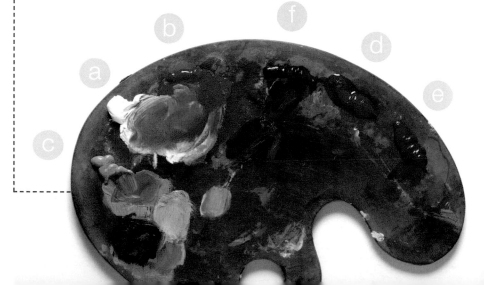

Yellow Emits Light

Yellow and yellow ochre are colors that often emit light, and they are usually used instead of white in mixtures where the artist wishes to preserve the intensity of a very saturated color. Using the yellows in this way works with greens, reds, and earth colors. Additionally, crimson with an added touch of cadmium yellow brightens the color and gives it a reddish tendency. However, this approach will not work with grays, blues, and violets since they counteract the yellow and transform it into a dark beige, green, or brown. Yellow can only brighten colors that are related to it, like green, ochre, sienna, orange, red, and crimson.

The basic range of yellows is created by mixing ochre, cadmium yellow, and orange, along with white.

It is not possible to paint with just yellows; it helps to mix them with small amounts of violet, green, orange, red, ochre, and crimson to create a large enough value scale.

Monochromatic Mixtures with Yellow

It is obvious that the yellows are the brightest, warmest, and most vibrant colors on the painter's palette. But it is difficult to create values, that is, it has a very reduced range of different values that run from the lightest to the darkest, unlike the cases of every other color. However, you can attempt to mix two or three different yellows (like lemon, cadmium, and real yellow), with other yellow colors with more orange tendencies, and even a light green.

Sunrise with **Lightened and Yellow Oil Colors**

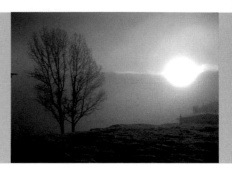

1. *The absence of significant details allows you to begin the exercise with a very simple drawing, a linear sketch made with a stick of vine charcoal. The sun, the outlines of the houses, the land, and the trees are barely drawn.*

The model is a winter image. The rays of the sun flood the scene and brighten the atmosphere with its light.

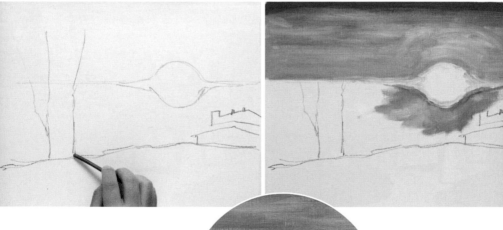

2. *Start painting at the top, first applying a band of indigo yellow paint that is gradated with a mixture of cadmium yellow and Naples yellow red, both of them very lightened. The brush marks should be barely perceptible.*

3. *The presence of white should be much greater around the sun. It is the source of light for the model and should give the impression that rays emanate from it.*

Now it is time to take on a somewhat more difficult challenge: painting in oils with a wide range of yellows. The following exercise uses two basic ones: Naples yellow red and cadmium yellow. Both are mixed with titanium white, cadmium orange, indigo yellow, ochre, and in certain cases, cobalt violet, which will give it a wide range of tones. Paintings that are almost exclusively made with yellows emit an extraordinary luminosity; therefore, it is important to choose a model that matches this particular situation.

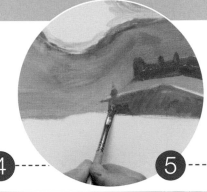

5. Violet is used lightly in the background. This way the yellow loses some warmth without losing its essential character. This does not happen with the houses. On them, the proportion of violet in the mixture is much greater than that of yellow since your goal is to make contrasting forms.

4 **5** **6**

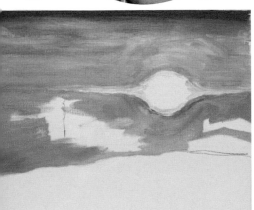
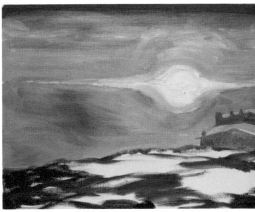

4. Obviously you cannot make a painting with only yellows. Now is the moment to bring in the violet, which is the complement to yellow on the color wheel. When added to the mixture, it will darken the tone in a harmonious manner.

6. Paint the sun with white lightly tinted with Naples yellow red, applying the paint thickly. Begin coving the foreground with long brushstrokes of a mixture of cadmium yellow, cadmium orange, and a touch of violet.

7. The illuminated areas in the foreground can be resolved by blending cadmium yellow and Naples yellow red. The brushstrokes should follow the direction of the shape of the ground that they describe.

8. The combination of light yellow and orange tones in the lower part of the painting help describe the irregular appearance of the terrain, while showing an interesting play of light and shadow.

THE YELLOWS EMIT AN EXTRAORDINARY LUMINOSITY

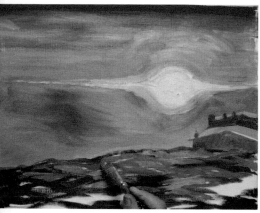

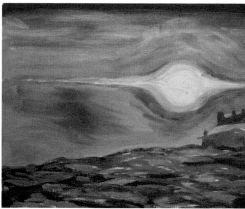

The array of tones and shades that can be made with such a limited color as yellow can be notably increased by introducing its complementary color, violet, into the mixtures.

9. *The trees on the left still need to be addressed. Use a mixture of orange and a little violet to paint the trunk and the branches. Charge the brush and angle it steeply to apply the paint, caressing the layer of wet paint.*

10. *On the trunk, the paint should be denser and more covering, whereas the ends of the branches can blend a little with the fresh paint under them. Notice how the finished painting illustrates an interesting approach to creating mixtures using yellow.*

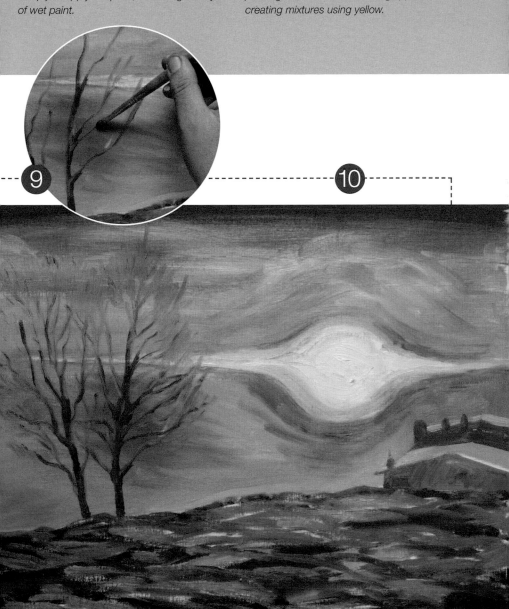

A Vase with Acrylics:
Families of Colors

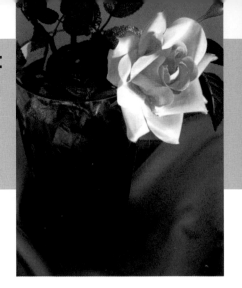

The model is a simple vase that has been cut in the framing to create an off-balance and original composition.

1

2

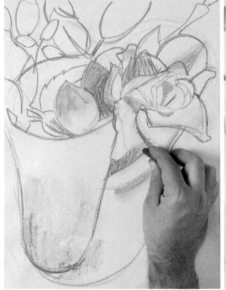

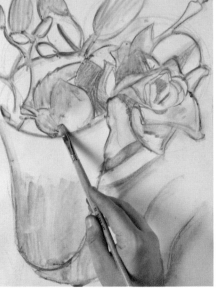

1. Make the drawing with light ultramarine blue chalk. The interpretation should be dynamic and expressive and show a certain amount of distortion.

2. Wet a brush with water and go over the drawing so that chalk dust will better penetrate the support and not alter the mixtures of acrylic paint.

A simple still life done in acrylics will help you learn to make mixtures with families of color or, in other words, to mix colors that are adjacent on the color wheel. This way of working, in addition to limiting the colors on the palette, allows you to maintain a strong harmony in the work and limits the colors in each mixture to no more than three. The resulting colors will look defined and clean and will not lose their natural strength.

The background of the still life is built up with a mixture of titanium white, sap green, and cerulean blue.

3

4

3. Make a mixture of sap green and cerulean blue lightened with white, dilute it a bit with water and apply it to the support. Change the proportions of the mixture as you go to create different tones.

4. Use cerulean blue and sap green to paint the leaves. Little by little the whitest areas will become more balanced dynamically as the darker strokes of color are added.

5. *Lighten the sap green with titanium green and a little white. You must use a finer brush to begin constructing the overlaid leaves, although the result should look very loose.*

6. *Complete the glass vase by combining titanium blue with cerulean blue, both thinned with a lot of water so that they will be transparent when they are applied.*

7. *After the greens and blues have dried, build up a varied range of pink tones to represent the flower. Distribute small applications of reddish color around the painting so that the pink flower will not clash with the work.*

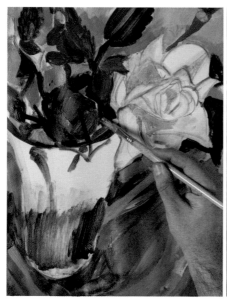

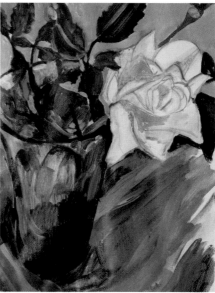

The dark tones on the vase are created with a mixture of cobalt blue and cerulean blue, with a small amount of added white.

The range of pinks can be created with mixtures of cadmium yellow orange, permanent red, titanium white, and real yellow mixed with some white.

8. The final result is a representation that mainly uses two families of color, the blues and greens that dominate the background, and the pinks and reds that draw attention to the flower and animate the scene with small contrasting dabs and highlights.

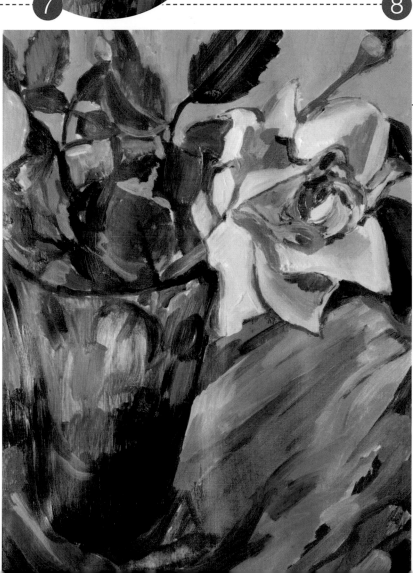

Mixing **Dark Colors**

Dark colors are not always made by adding black or burnt umber to the mixture, which at first may seem like the easiest solution. There are many ways to darken a color, and it is important to know which color to use in each case. You must learn to darken without affecting the saturation or muddying the resulting color too much. Here are some approaches.

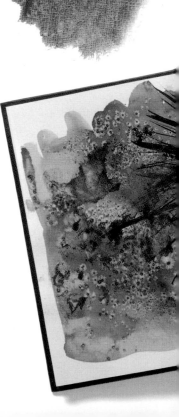

Some artists choose to add Payne's gray to their palette instead of black, since it is more transparent and does not alter the mixtures as much.

Payne's gray can be mixed with other colors in small amounts to create a range of grayish colors that maintain their strength despite being darkened.

The Example of Black

Mixing colors with any of the varieties of black (ivory or lamp, etc.) creates grays that are too muddy. The strength of the black pigments is very intense and they overpower the colors they are mixed with, so they should be used carefully. In mixtures that include black, it is a good idea to add a touch of white to clear it. This will allow you to recapture some of the color absorbed by the black and keep the blended colors from being too dark. It is easier to perceive the shades of a color when it is a light tone than when it is very dark.

Darkening Mixtures with Other Colors

Unless it is strictly necessary, you should avoid the use of black and burnt umber for the sole use of darkening colors. Burnt umber will only make sense when you must darken colors from the same range, like ochre and sienna, which are much lighter. This principle can be applied to the blue and green ranges. Sap green, dark alizarin crimson, and dark ultramarine blue can also be used to darken earth tones, while alizarin crimson and permanent violet can be used to do the same with oranges and reds.

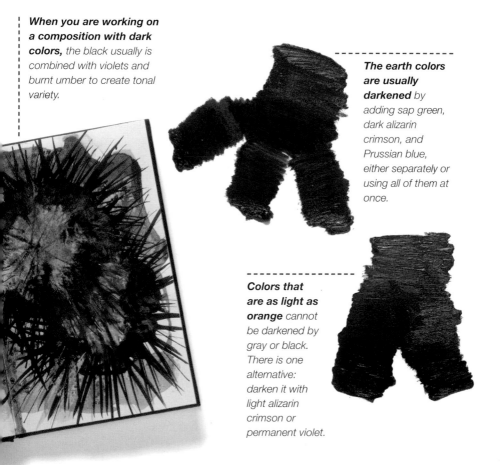

When you are working on a composition with dark colors, the black usually is combined with violets and burnt umber to create tonal variety.

The earth colors are usually darkened by adding sap green, dark alizarin crimson, and Prussian blue, either separately or using all of them at once.

Colors that are as light as orange cannot be darkened by gray or black. There is one alternative: darken it with light alizarin crimson or permanent violet.

The Problem with **the Greens**

There are barely ten green pigments used to manufacture oil paint, but combined with other pigments they generate an endless number of different colors. You can start with yellow and blue, which are the two colors that make green, but you can also add such disparate colors as crimson, orange, and violet to the mixture.

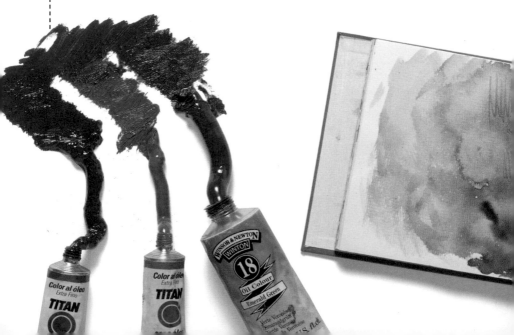

Experienced landscape painters rarely use colors directly from the tube because they have very artificial tones that are not very similar to natural greens.

A saturated green can be lightened by just adding a small amount of ochre or orange. The addition of light brown colors is the most common way of making green look more natural.

The Original Pigment

The greens are the colors that cause the most problems for artists. This is because, except in a few cases, the pure greens contained in the tubes and jars of paint normally have a level of saturation that gives them an artificial look. Their appearance has little to do with the range of greens in nature and a lot with objects manufactured in glass and plastic that also uses the same pigments in their pure state. The range of natural greens is softer, more neutral, and much wider, sometimes even too much so. However, all these tonalities can be created with very few pigments mixed with other colors in small proportions.

The Many Possibilities of Green

Experienced painters will rarely use greens directly from the tube; they usually shade them with other colors to reduce their strength. They lighten them with Naples yellow red, cadmium yellow, or ochre instead of using white, which tends to make everything gray. The blues and dark violets are used to darken them, and it is not even strange to mix them with a little orange or raw sienna to create brown tones. Burnt sienna is also a good color for mixing with green because it creates a very warm earthy green.

In nature, the greens look somewhat softer and have some gray, brown, blue, or even violet in them.

Starting with a single green, as a base color, you can create an extraordinary range of shades with the addition of a small amount of other colors.

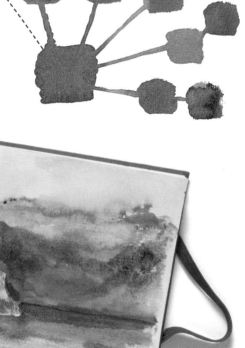

High **Key Colors**

The term "high key" refers to the brightness and saturation of the color. This range of colors is lightened by the addition of whitened colors to the mixtures, which, while reducing the strength of the

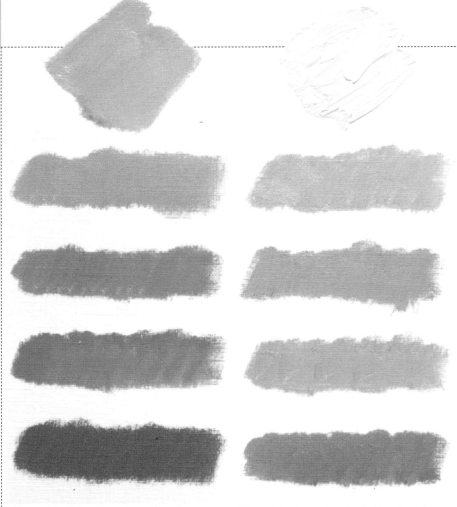

Instead of mixing the colors with white, we have used Naples yellow red (a very light yellow), and the result is a range of warmer colors. The yellow reverberates a little in all the mixtures.

The quickest way to mitigate the strength of a color is to add a small amount of white. This will cool the color and reduce its contrast with respect to the white support on which you are painting. The result is a range of very soft, pleasant looking pastels.

color, create a group of strongly harmonious colors. High key paint seems softer and more pastel, but it also offers a more delicate and subtle version of the colors.

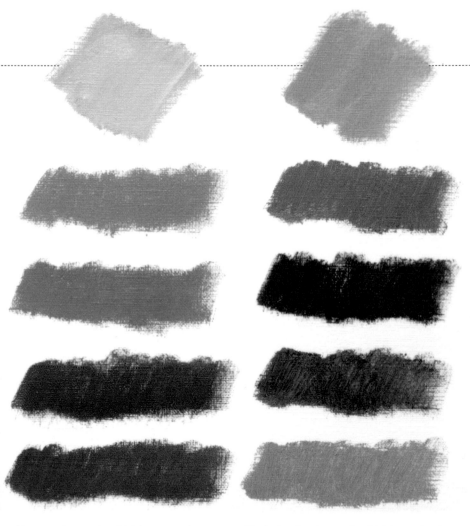

You can also create a high key range by mixing the colors with a very light gray. Here, in addition to making them lighter, the intervention of the gray creates a neutral color, much less brighter than the previous cases.

The last option for creating high key colors is to add Naples yellow red to the mixture. You must proceed with caution, since the orange tone of this color tends to turn the greens and blues to gray.

Interior in Red
with Acrylics

This interior space softly illuminated from the side creates an interesting play of shadows.

1 **2** **3**

1. The composition should be directly applied with a brush, using a little bit of black and a few lines made with cerulean blue.

2. Cover the walls with a mixture of cadmium red, phthalate red, and quinacridone pink, using very gestural strokes and varying the amount of water used to dilute the paint.

3. The shadows that are projected by the chairs on the floor and appear on the wall in the background are suggested with alizarin crimson, to which has been added a touch of blue and another of yellow.

The chromatic strength of the reds is obvious on any palette. Since it is one of the strongest colors, it dominates the colors in any mixture to which it is added. It instills warmth and a feeling of energy and positivity that should be used for communicating a feeling of warmth and comfort in an interior. This exercise with acrylics attempts to develop a range of reds to paint a furnished interior, illuminated by a light that comes in through a small window at one side.

4. Mix the cadmium red with a large amount of white. Even though the dominant color will be red, this does not mean that you cannot incorporate areas of green paint for contrast.

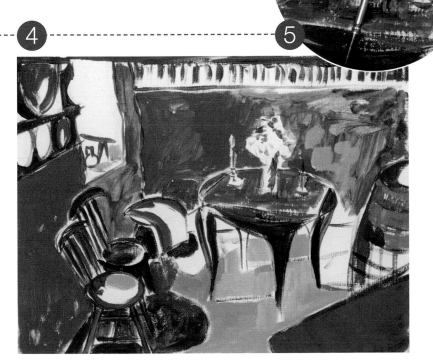

5. The illuminated areas should be built up with areas of color created by mixing red or crimson with titanium white. You can make the pinks warmer by adding a touch of ochre. Since green is the complementary color of red, its presence right in the center of the scene is strengthened.

THE CHROMATIC STRENGTH OF THE REDS

7. You do not have to worry about detail; the forms should be constructed by superimposing brushstrokes that are more or less accurate.

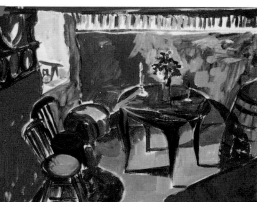

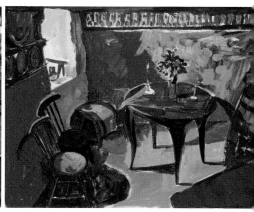

6. To paint the table and the chairs, add a bit of burnt umber and violet, which will cause the red to be stronger. Finish the other areas with strokes that are grayish with a certain crimson tone.

8. The fast-drying acrylic paint will keep you from doing more delicate blending. The strokes of color proceed one after another, jumping from one tone to another with energetic brushstrokes.

9. *The final applications of color will be made with a finer brush. Now is the time to go over the shapes of the furniture and finish covering the spaces where the white of the support are still visible.*

10. *No color attracts your attention like red. For this reason, you must control how much you use when it is saturated and know how to balance it with variations in tone where it is mixed with white, violet, sienna, blue, and even green.*

9

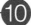

When to Use **White**

Beginning artists mainly use the color white in a systematic way, to lighten colors. But they must keep in mind that it also makes colors look pasty and reduces the chromatic energy in the painting. It can be used in large amounts only when it is justified by the chosen subject or if the dynamism you wish to instill in the painting requires it.

It is best not to overuse white in the mixtures and to find other ways to lighten colors. Green can be lightened with yellow (a), violet with cyan blue (b), and Van Dyck brown with ochre (c).

White changes cadmium red into a very dull pink (d). Yellow, on the other hand, makes it move toward orange without reducing its chromatic strength (e).

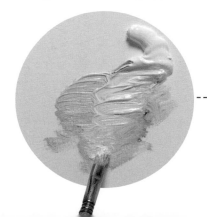

Rarely does pure white appear in paintings. It is usually tinted with small amounts of other colors so it will stand out from the color of the support.

White in Mixing

The best way to lighten a color without causing it to lose strength is to add another adjacent color. Thus, a green can be mixed with yellow, a dark violet with cerulean blue, and burnt umber with ochre or orange. The use of white alone would only be advisable when you wish to lighten a color that is already light, like yellow, or when you wish to tone down a color to create a range of pastel tones: high key colors.

Subtle Whites

Nowadays some artists use the color white as a central theme in their work, giving it an importance that is not very common. In these cases, titanium white becomes the main protagonist of the mixtures, barely shaded with simple brushstrokes of other colors. It is usually applied thick and heavy, without strong contrasts or the use of other strong colors. White surrounds everything, submerging the viewer in an atmosphere of perpetual light. If you are going to try this, it is important to make your drawing with a light color instead of charcoal and to not completely cover the lines so that the original form of the model does not disappear among the barely contrasting strokes of white.

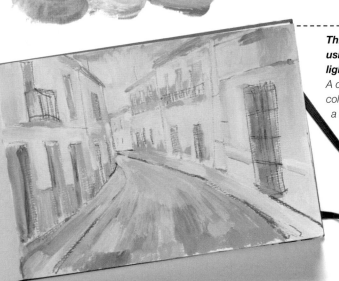

Mixtures with a lot of white create a range of pastel colors *or high key colors that can be used as a technique that is harmonious and expressive in the same painting.*

This painting was made using high key colors lightened with white. *A dynamic of such light colors gives the scene a strong sense of light, which is reminiscent of an overexposed photograph.*

Interpreting
Color
on the Model

Once you have understood how colors interact with each other and what the possibilities are when they are mixed, you can apply the techniques on a painting. In this next section, we will present different techniques for sharpening the eye, for correctly interpreting colors, and for optimizing how they are mixed on the palette. This will require combining the artist's interpretation of the subject with his or her technique with the brush, which is important for creating a universe of colors that are adapted to the requirements of each model. All artists need to have a practical knowledge of color, and the only effective way of gaining it is to experiment on the palette using the trial and error method.

Developing a **Universe of Mixtures**

After a beginning artist has been painting for a few years, he or she should become familiar with the properties of all the colors and learn to discern which ones would work best in each case, including choosing the right colors to mix in matching the real model. It is not a matter of analyzing the characteristics of the colors but of learning how they act on the palette when you are trying to create an accurate range of colors.

This early morning rural scene is clearly dominated by bluish light. The blues should be in the center of this universe of colors. From there you can begin shading by adding grays, crimson, and English red.

The light at dusk creates warm greens *on the mountaintop, which can be created by mixing cinnabar green and cadmium green with orange and Naples yellow red. Then you can create some blues for the sky and dark neutral greens for the shadows.*

Choosing Colors Based on the Model

The first step is to observe the model and to identify the two or three dominant colors, those that are repeated the most or that relate to the general tone of the overall scene. Then add two or three more colors to shade and lighten the others and in this way create a wide range of tones that can be adjusted to the variations in the colors of the model. Obviously, when a color is very intense and dark, it is best to use it in small quantities.

Creating Colors Based on Photographs

For practice, it can be helpful to take three or four different photographs and select a range of colors that match the colors in the pictures. First, identify the most evident colors, those that occupy the most space in the work (the sky, the mountains, or the clouds) and then make some new mixtures around them that extend the most representative shades and changes in tone. It is a way of checking the coloring power of each color, its opacity, and it allows you to see the notable differences between the mixtures made with one color or another.

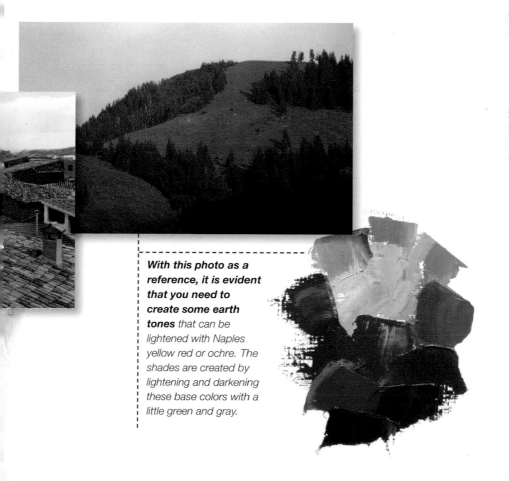

With this photo as a reference, it is evident that you need to create some earth tones that can be lightened with Naples yellow red or ochre. The shades are created by lightening and darkening these base colors with a little green and gray.

Progressively Adjusting the Colors

The first application of paint will establish the dominant color of the painting and will affect the mixtures that you will be adding. Although the preparation of the colors will mainly take place on the palette, it is on the canvas where each tone will blend with the colors near it to create the desired look.

Using these three groups of color as an example, we will explain how to mix the colors for a painting. The first application should be diluted and monochromatic (1).

The previous layer of paint is then gone over with three generic colors, some of which can begin to be blended with the adjacent colors (2).

Now the general coloring is completed, and you can focus on the shading. Use new mixtures to make some changes in tone over the previous colors, blending them directly on the surface of the painting while the paint is still wet (3).

This is a quickly applied start of a complicated subject, with many figures. Simple general areas of paint are applied over a drawing done with a blue wash to the background as well as some skin tones (1).

The First Application

During the first application of paint, with oils or acrylics, the colors should be quite diluted. In this phase, the color mixtures should be approximate and not necessarily exact. It is a matter of a first visualization of the coloring of the painting. Besides laying down a base color that will fix the brushstrokes made during the drawing phase, it will set the direction that the representation will take. The first application will suggest the model with broad strokes of paint, as if it were a puzzle that is being filled in, that looks more like an abstraction than a realistic painting.

Adjusting the Colors

Over the first application, begin adjusting the colors by adding new mixtures of thicker paint. At this point, there are two interpretive options: a naturalist one that leans toward adjusting the colors to the actual model without much margin for error and a colorist approach where the artist makes a freer interpretation by incorporating chromatic combinations that do not appear in the model to create a more personal and attractive work. If the coloring is correct, the way the painting is finished will entirely depend on the artist's intention.

The flattest areas of color are developed by creating gradations or by overlaying new colors. The treatment is very loose and abstract (2).

Just two values are created to describe the clothing. In this phase, the broad strokes of the painting have been finished. You can leave it this way as if it were a sketch, or you can continue resolving the work and adding details (3).

Choosing the **Dominant Range**

The subjects that we usually paint contain different and diverse colors that sometimes can even clash or create surprising contrasts. As an artist, you must learn to be selective, limiting the colors that are used on the palette and trying to organize them by using a more or less harmonious range, which means choosing a group of dominant colors that will unify the mixtures.

The first range we use has various colors, although the dominant range is red, which will be mixed with the rest of the colors.

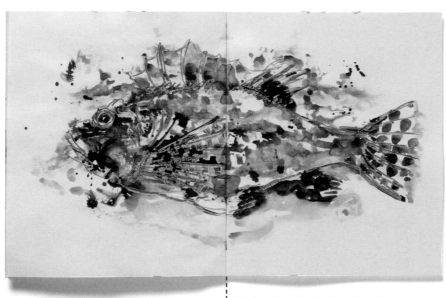

Notice that the pink, red, and orange colors of the fish have subtle shades; however, the red acts as the dominant color and creates an overall dynamic in the painting.

Harmonizing the Colors

The intention of the artist always prevails over the colors of the actual model, since he or she is the one who is imposing order and adding personal taste in the combinations. All the mixtures made on the palette should aspire to a natural harmony, a close relationship between the tones of a same family of color. The simplest approach is to work with just analogous colors, which are adjacent to each other on the color wheel, because this will give them a strong unity. The inconvenience is that this limits the variety of colors. Another option is to always add a small amount of the same color to all the mixtures. The presence of this color tends to bring all the chromatic combinations closer together.

Practical Examples

It is possible to harmonize a painting based on a previously established chromatic scheme. The artist will observe the model and choose the colors that he or she will use in the exercise beforehand and reject those that seem to clash. The chosen colors will be placed in the margin of a piece of paper to form a chromatic scale so their usefulness can be analyzed in isolation, how they relate to one another, and if the color chart looks like it adheres to the criteria of unity while still offering variety. Starting from here, they can be applied to the painting in a way that they will relate to each other and work together.

This other color palette will work for painting a landscape. Previously isolating the colors will let you check their usefulness and harmonization, so you avoid any dissonance in the painting.

This watercolor landscape was made after previously choosing the colors. The drawing was made first with a light blue wax crayon, which gives the work a less traditional look.

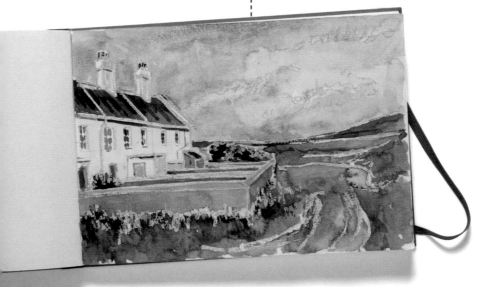

Developing the **Tones on the Palette**

In this section, we will look into the technique used for mixing the colors on the palette. We will offer clear instructions on how to develop different tonalities in a quick and effective manner and, what is more important, without wasting a great amount of paint nor using too much of the space where the mixing is done.

Mix two basic colors, cadmium yellow *and dark green, in equal proportions to make a medium green. This is the base color that you will use to make more tones (1).*

To create a shade place the brush near the edge of the base color, and there move it in a circular motion, never beginning in the center. In this case, we have added Naples yellow red to the green (2).

Here is a new satellite color. Work at the edges of the mixture; first add a touch of cyan blue and then drag in some green with the brush so that both colors mix to make a new color (3).

A Nucleus of Paint

The base paint should be mixed in the center of the palette and should be no larger than about 2 inches (5 centimeters) in diameter. It should have two or three colors, no more, that are blended by moving the brush in circular motions to keep the area from getting larger with each movement of the brush. It is important to continue to control the edges; otherwise, just a few mixtures will use up the entire usable surface of the palette.

The third intervention consists of blending the green base color with orange. We have created four variations of color without wasting any space on the palette (4).

Satellite Colors

When you start mixing, it is important to make satellite colors. This means that instead of beginning in the center of the base mixture, you make another new one right on the edge of it. This is done by charging the brush with a little of the paint from the base mixture and then adding the new color, making circular brushstrokes until you make a new variation, a shade that is different from the previous one. This way you can preserve the color of the first mixture and save paint, since it is better to work on the edge of the base mixture at a smaller scale than having to add paint to modify the entire base color. By the end, a mixture can have three or four satellite colors with slight variations of the original color.

The satellite colors can become as large as you want, and one side of them can even be lightened with some white. Despite the number of shades that have been made, the base color is still preserved in the center, and you can go back to it again if you need to (5).

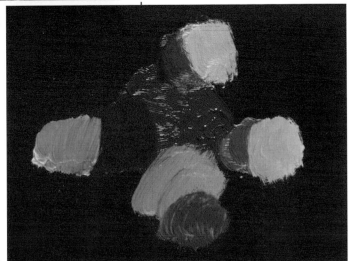

How to Resolve **Chromatic Monotony**

Some beginning painters find it difficult to decide which colors to make to break up the chromatic monotony, while avoiding the easy approach of darkening with brown and lightening with white to increase the number of tones on the palette. In the following section, we suggest using harmonic triads for achieving interesting results and making a painting with creative colors and composition.

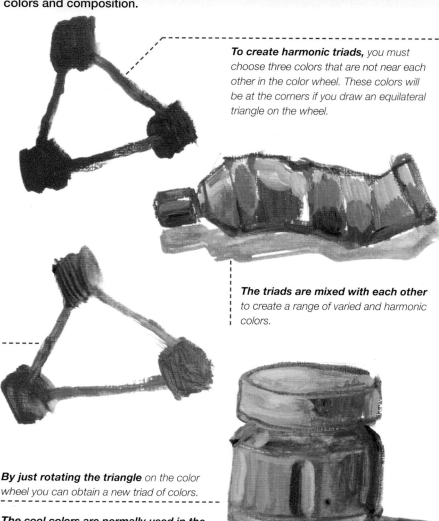

To create harmonic triads, *you must choose three colors that are not near each other in the color wheel. These colors will be at the corners if you draw an equilateral triangle on the wheel.*

The triads are mixed with each other *to create a range of varied and harmonic colors.*

By just rotating the triangle *on the color wheel you can obtain a new triad of colors.*

The cool colors are normally used in the shaded areas of the objects, *whereas the warm ones are generally used on the illuminated surfaces.*

Harmonic Triads

To keep from becoming too monochromatic, you should choose colors that communicate opposite feelings and emotions, which means working with a couple of cool colors and a couple more of warm ones. This way the feeling of calmness and monotony transmitted by the cool range of colors can be balanced by the excitement of the warm colors. How do you choose three colors for the mixtures? It is simple. Take three colors that end up on the corners when you draw an equilateral triangle on a color wheel. The combination and the mixture of these three colors allow you to create harmony in any painting without the danger of making a dull or monotonous work.

The Triads in Practice

In this case, we have decided to paint a squid using a range of violets, browns, and reds, which are a harmonious combination. Upon examining the color wheel, we selected a pair of colors that strongly contrast with each other, for example green and ultramarine blue, which form a harmonic triad with the more reddish tones. Next, these two colors were added to the range of browns and violets that were previously established. The blue will be used for making some shadows and complementing the strong reds, and the green for painting the background and contrasting with the shape of the squid. The colors do not always have to be mixed; they can also be used by themselves to add chromatic variety to the work and to make more accentuated contrasts.

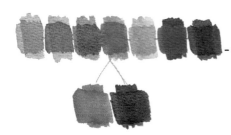

A practical exercise with acrylics consists of choosing a chromatic scale before starting to paint. Here we have selected analogous browns, violets, and reds. To break up the monotony, we introduced a green and an ultramarine blue that will form a harmonic triad with the more reddish tones.

Paint the body of the squid, simply, using the range of selected analogous colors to which you can add a little ultramarine blue on some of the tentacles to create some tonal variety. The background can be painted with variations of green that will emphasize the shape of the squid.

LET'S EXPERIMENT

The Greens in a Landscape

The model is a Nordic landscape with a lot of green, which is in strong contrast with a red house in the foreground.

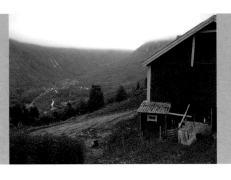

1. The model is so simple that it can be approached directly with a brush. Use violet oil paint diluted with turpentine to draw a few lines that will determine the grounds.

2. Since it is a cloudy day, only tiny amounts of yellow are used. The greens are lightened with a very light gray, which you can see in the foreground. This is the same gray used to paint the sky.

3. Use a neutral medium tone gray to paint the mountains in the background by applying a very uniform layer of color.

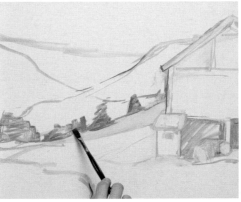

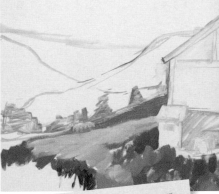

On a separate sheet of paper, you should study the composition, the tonal values of the model, and a possible chromatic approach using oil pastels before painting. It is always a good idea to plan before painting.

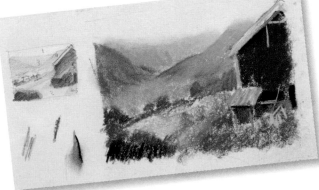

Faced with the difficult challenge of representing a landscape flooded with the innumerable greens of the vegetation, there are two approaches you should keep in mind so that the mixtures do not become monotonous and reduce the variety of colors in the subject. You should use two or three greens as base colors and mix them with others to increase the range in a harmonious way. In this exercise painted in oils, the use of apparently dissimilar colors mixed with green can create new shades that are neither dissonant nor monotonous.

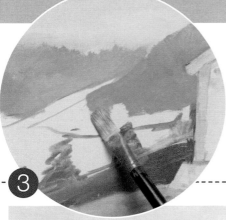

4. Use a combination of titanium and sap greens for the bush on the left, and for the walls of the house use sienna mixed with violet. In the background, mix the light gray with cinnabar green and turquoise blue.

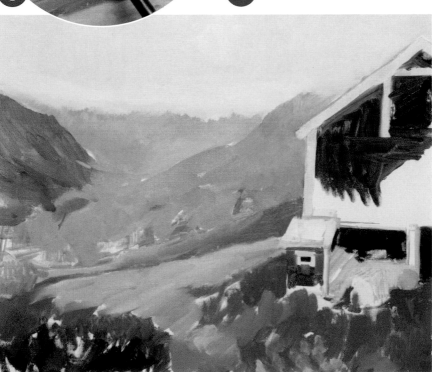

5. *Finish the wall of the house with a mixture of burnt sienna, violet, and a touch of crimson, applying vertical strokes to simulate the texture of the boards used to make the house.*

6. *The trees in the background are built up with a combination of sap green, cinnabar green, and gray. They are simply sketched with a few brushstrokes.*

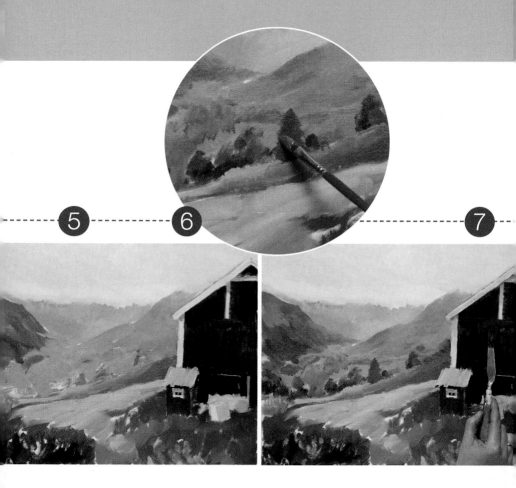

7. *In the background, make a clear transition from green to gray, with shades of sienna on the sides of the mountains. Scratch the lines of the wood house in the layer of wet paint with a spatula.*

8. *The final details consist of painting the fence posts gray in the foreground and the ones that are farther away with the tip of a charcoal stick.*

9. *In the finished work, the gray, the sienna, and the greens used to create the landscape support and blend with each other to create a very harmonious representation with many tones that all move in the same direction.*

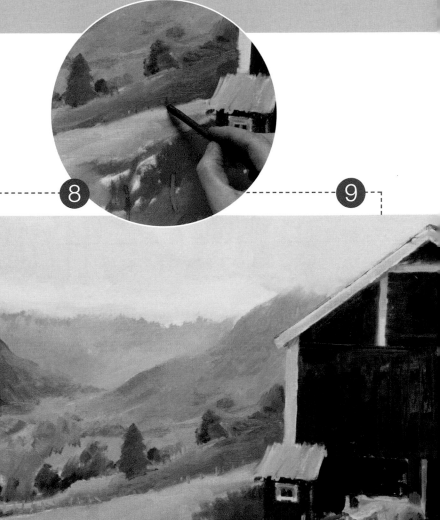

Thomas Moran
(1837-1926)

This American painter and engraver belonged to the Hudson River School, a genuinely American group of painters influenced by the

Thomas Moran was extremely fascinated by the wild landscapes of the United States.

Portneuf Canyon, Idaho *(1879)*
This watercolor landscape depicts the grandeur and immensity of America's natural open spaces. Moran made many sketches and color studies like this one during his journeys through the wilderness of the United States. The common denominator of his work is his great interest in color, working with subtle mixtures that frequently incorporated oranges and violets to create contrast between the most illuminated areas of the mountains and the other parts of the composition that were in shadow. This interest in capturing the colors of nature gives his paintings an overwhelming feeling of strength and power.

1. All good watercolorists should begin by painting the sky with a more or less uniform wash of ultramarine blue lightly shaded with crimson.

aesthetics of European Romanticism in the mid-19th century. He started working as an artist as a wood engraver and illustrator for different magazines, a craft that helped him launch his career as one of the foremost American landscape painters. Making use of lavish and exquisite colors, Thomas Moran represented the wilderness of the American continent in its pure state, before the "white man" would change it in the name of progress. The influence of William Turner can be seen in his work, especially in the use of color and the choice of the landscapes.

CAPTURING THE COLORS OF NATURE

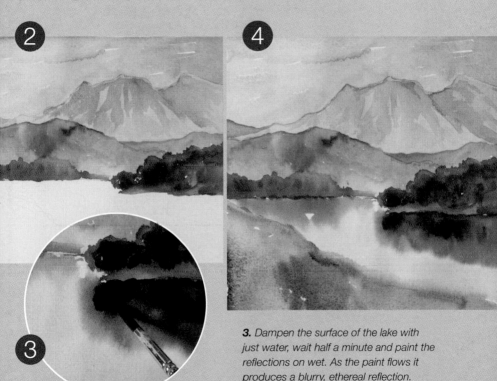

3. Dampen the surface of the lake with just water, wait half a minute and paint the reflections on wet. As the paint flows it produces a blurry, ethereal reflection.

2. After the sky is dry, work on the mountains in the background with very light washes. In the middle ground, the mixing of colors is done wet, directly on the support.

4. Finally, finish the sand in the foreground with mixtures on wet of ochre, burnt umber, and ultramarine blue. Although this is one of Moran's least detailed works, it preserves a lively spirit.

*"Painting contains three main parts, which we call design, measure, and color. [. . .]
By coloring we designate how the colors are seen on objects, and their lights and
shadows when the light changes."*
Pier della Francesca:
On Perspective for Painting, 1472–1475